TYNEMOUTH &
CULLERCOATS
HISTORY TOUR

The book is dedicated to all those who have given their lives for others while carrying out rescues for the Tynemouth Voluntary Life Brigade and the Cullercoats Lifeboat Station. All royalties from the sale of this book will be split evenly between both organisations.

First published 2016

Amberley Publishing
The Hill, Stroud,
Gloucestershire, GL5 4EP
www.amberley-books.com

Copyright © Ken Hutchinson, 2016
Map contains Ordnance Survey data
© Crown copyright and database
right [2016]

The right of Ken Hutchinson to be
identified as the Author of this work
has been asserted in accordance with
the Copyrights, Designs and Patents
Act 1988.

ISBN 978 1 4456 5775 2 (print)
ISBN 978 1 4456 5776 9 (ebook)

British Library Cataloguing in
Publication Data.
A catalogue record for this book is
available from the British Library.

Typesetting by Amberley Publishing.
Printed in Great Britain.

INTRODUCTION

Tynemouth and Cullercoats are two ancient coastal villages that are linked by a seafront trail which forms the inspiration for this book.

Tynemouth

Tynemouth as its name suggests developed on the north bank of the River Tyne where the river mouth meets the North Sea. The striking headland has been occupied for thousands of years. The Romans built a lighthouse here. An Anglican monastery was established in the seventh century and it was raided by the Danes and destroyed in 875. The Vikings raided the settlement and the Normans built a castle here. Tynemouth Priory was established on the site as a Benedictine priory in 1085 and was a wealthy monastery before it was largely demolished in 1539 by Henry VIII. It is believed that three kings have been buried in Tynemouth, namely St Oswin, King of Diera in 651, St Osred, King of Northumbria in 792 and Malcolm III of Scotland in 1093. The town of Tynemouth originally developed on either side of the main street leading to the castle.

When the railways reached Tynemouth in the late 1840s the town developed rapidly, both as a residential commuter town for Newcastle but also as a visitor attraction. Tynemouth Volunteer Life Brigade was the first of its kind in the world, established in 1864 following a number of shipwrecks. The North Pier was finished in 1909.

Cullercoats

The name of Cullercoats is said to originate from 'culfre-cots' meaning dove cotes or dove houses. The village was originally owned by Tynemouth Priory but later by Thomas Dove, where the name may also have originated. The harbour was used at one time to export coal from local pits as well as limestone from Marden Quarry via waggonways.

In addition, salt production using salt pans, fuelled by burning local coal was important in the seventeenth century. Cullercoats with its natural harbour has been the home to fishermen for hundreds of years and still has a small number of working boats. The beauty of the coastline and the good light attracted a number of famous artists to Cullercoats in the late nineteenth century. It became an artist's colony and the most famous artist to live here was the American Winslow Homer who painted many famous local scenes that have made Cullercoats famous throughout the world. The village developed as a tourist resort and commuter centre following the arrival of the railway in 1882. The Duke of Northumberland paid for the establishment of a lifeboat in 1852 and also built the magnificent St George's Church in 1884.

I was asked to write this book following the success of *Tynemouth & Cullercoats Through Time* in 2011. I am a Newcastle City Guide and each year the guides undertake over forty different guided walks in Newcastle and surrounding towns including both Tynemouth and Cullercoats. Details of all walks can be found on the Newcastle City Guides website www.newcastlegateshead.com/city-guides. I am also a member of Tynemouth Antiquarians and Historical Society who meet in the Kings School, Tynemouth on the second Wednesday of the month at 7.15 p.m., October–April each year; new members and visitors are always welcome.

As with any book of this type there will inevitably be some errors for which I apologise in advance as I have not been able to check every name, date or detail at the original source.

Ken Hutchinson
March 2016

ACKNOWLEDGEMENTS

Special thanks go to Diane Leggett and Martyn Hurst from the Local Studies section of North Tyneside Libraries for their help and encouragement and for allowing me to use many of the photographs from their collection which they have built up since 1974. Many of the photos used have been donated by members of the public and library staff are always on the lookout for additional pictures to add to their collection. Thanks also to Sarah Mulligan from Newcastle City Libraries for allowing me to use pictures of the Spanish Battery and the old 1847 Tynemouth Station from their photograph collection. Thanks go to the staff at Amberley Publishing for asking me to write the book and for help in producing it. Again, many thanks go to my family especially my wife Pauline for proofreading the text, my sons Peter and David for their encouragement and not forgetting my granddaughter Isla who loves the beaches.

Cullercoats

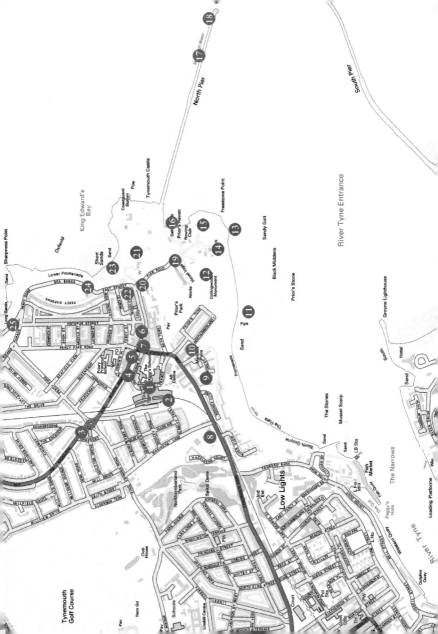

1. TYNEMOUTH STATION

The present Tynemouth Station was opened in 1882 as part of the new Tyneside Loop Railway linking the coast to Newcastle and which now forms part of the Metro system. It was the grandest station on the new railway and the cathedral of glass was adorned with plants lovingly cared for by staff who also welcomed thousands of day trippers from Tyneside. It has recently been restored to its former glory and hosts very popular markets every weekend.

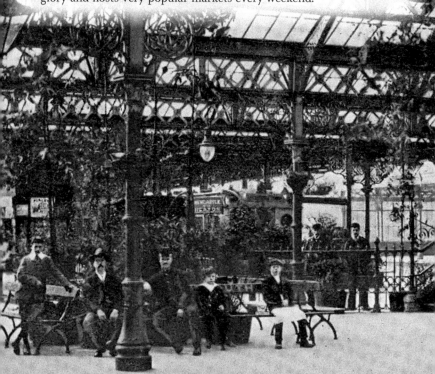

Tynemouth Station.

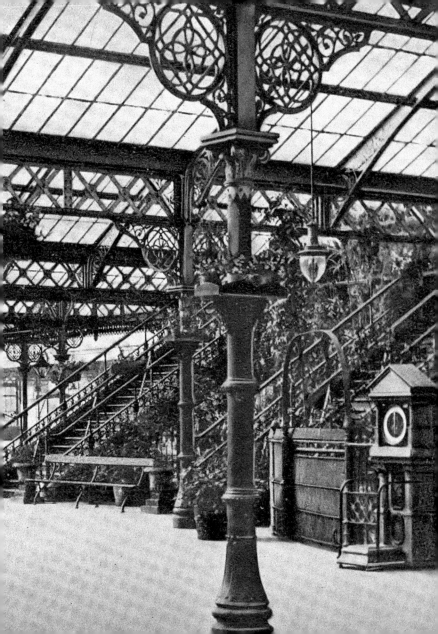

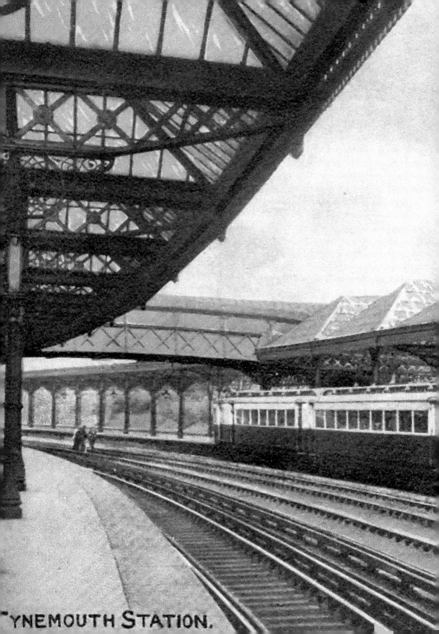

YNEMOUTH STATION.

2. ELECTRIC TRAIN AT TYNEMOUTH STATION

The first electric trains were introduced to the Tyneside Loop in 1904 and continued for decades until they were replaced by diesel trains. When the present Metro System was developed in the 1980s electrification was again introduced, this time, with overhead lines rather than the original trackside lines. The magnificent glass canopies were under severe threat of demolition at this time as they were in poor condition and much larger than what was needed for a Metro halt. Public concern and numerous grants led to their preservation and restoration over the years.

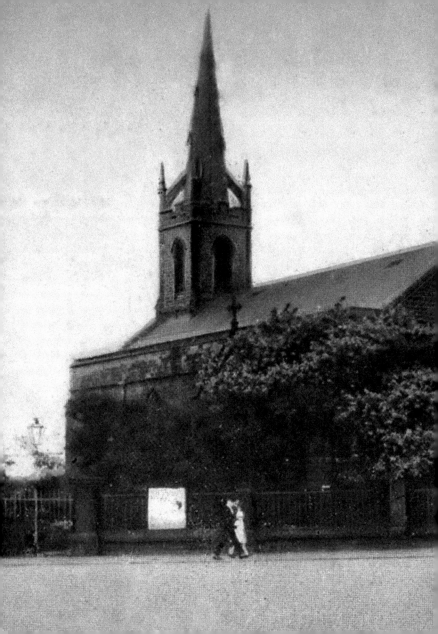

3. HOLY SAVIOUR'S CHURCH

Built in 1841 for the Duke of Northumberland on what was then the edge of the village of Tynemouth just beyond the Manor House (replaced by houses on Manor Road). Before this village residents had to travel to Christ Church in North Shields. At this time Tynemouth was developing beyond the original settlement around Front Street and when the railway arrived in 1847 further extensive residential development took place. The spire was removed in 1957 when it became unstable.

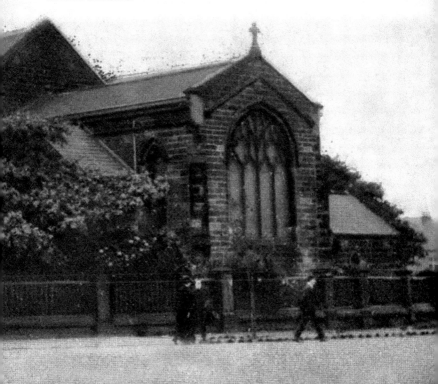

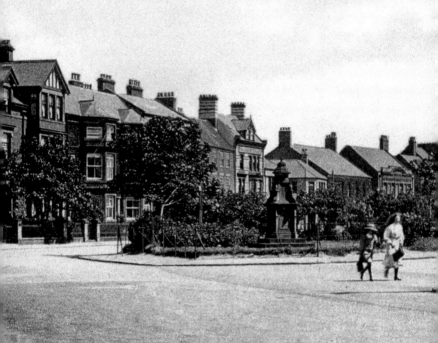

Huntington

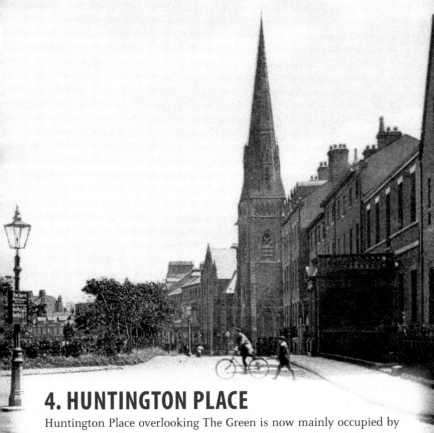

4. HUNTINGTON PLACE

Huntington Place overlooking The Green is now mainly occupied by King's Priory School but was originally built as high-class residential properties for well-to-do residents and their servants. The large central building with the portico was originally Tynemouth House with extensive grounds and owned at one time by an iron manufacturer called George Crawshay whose company provided the iron for the high-level bridge in Newcastle. Giuseppe Garibaldi the famous Italian freedom fighter visited the house in 1854.

5. QUEEN VICTORIA STATUE, FRONT STREET

The statue of Queen Victoria by Alfred Turner was erected in 1902 the year after she died. The area around it forms part of The Green's open space at the end of Front Street that also includes two other monuments, one to the Boer War while the other war memorial records the victims of the First and Second World Wars. The area was given a £280,000 facelift in the early 2000s as part of a six-year Tynemouth Conservation Area improvement scheme which saw paths improved and additional cobbles on Huntingdon Place.

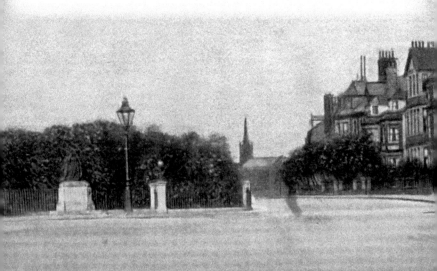

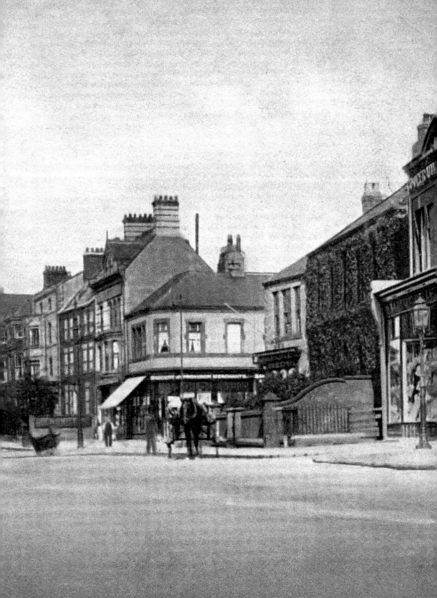

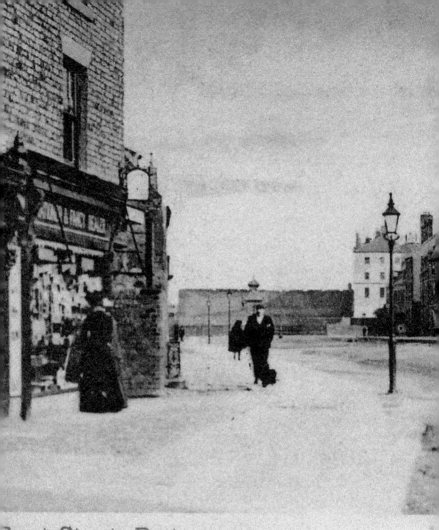

Front Street, East.

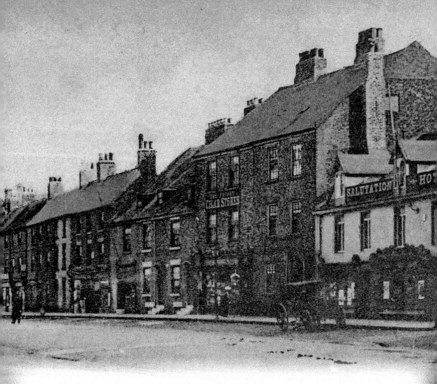

6. FRONT STREET LOOKING EAST TOWARDS CASTLE

Unlike today, there is only one car parked in Front Street in 1910. The Salutation Inn is in the same place as it was over 100 years ago and many of the buildings still exist as well. One exception is the gap that now exists in front of Our Lady & St Oswin's Roman Catholic Church which was occupied by buildings at that time. The postcard was produced by a local man called Mathew Auty who had his shop on Front Street close to the shop on the left.

7. FRONT STREET LOOKING WEST TOWARDS CONGREGATIONAL CHURCH

The shops and other buildings have not changed a lot over the last century. The Congregational Church built in 1868 has lost the top of its tower and has been converted into a shopping mall. The most striking difference today is how much the trees have grown and how many cars occupy any vacant space in the highway.

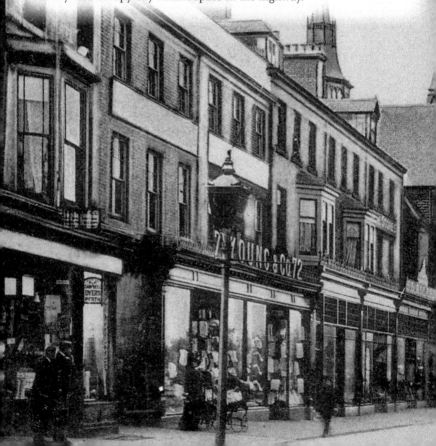

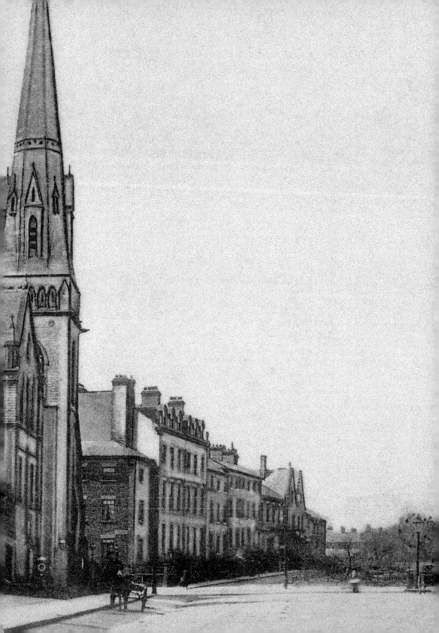

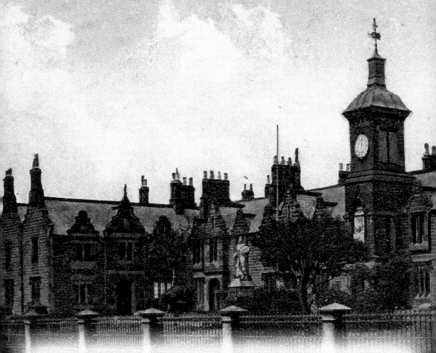

8. MASTER MARINERS' ASYLUM

This early social housing scheme dates back to 1837 and was built by the Duke of Northumberland to provide housing for master mariners and their families. These men had in many cases spent most of their lives at sea and had nowhere to live when their days at sea came to an end. They were designed by Newcastle architects John and Benjamin Green who designed the Theatre Royal and Grey's Monument.

35362 (J.V.)

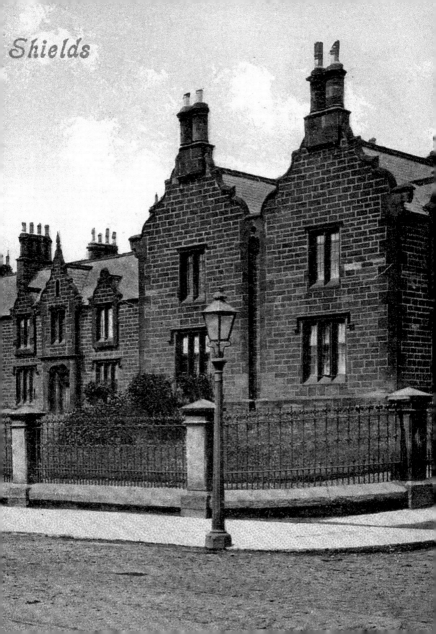

Shields

9. ORIGINAL 1847 TYNEMOUTH STATION

The first main station into Tynemouth terminated at Oxford Street, when it was extended from North Shields in 1847, ten years after the railway reached North Shields from Newcastle. This view is looking east along the tracks at the rear of the main station buildings that still exist today beside the taller building to the south that was the former station hotel. The building of the Tyneside Loop in 1882 and the new station took the passenger trade away and this became the Oxford Street goods yard.

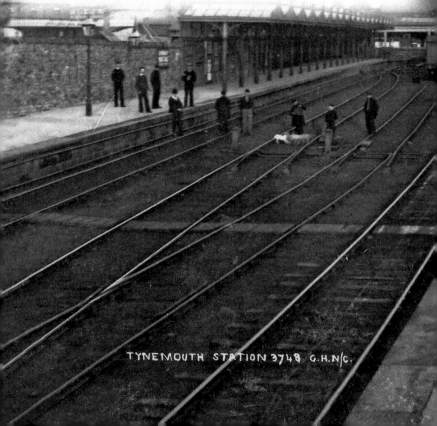

TYNEMOUTH STATION 3748 G.H.N/C.

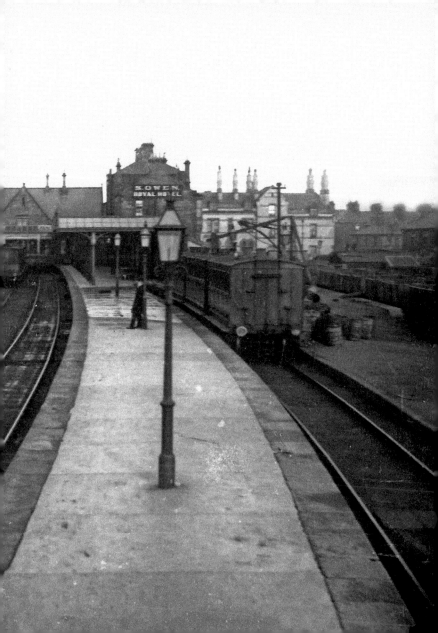

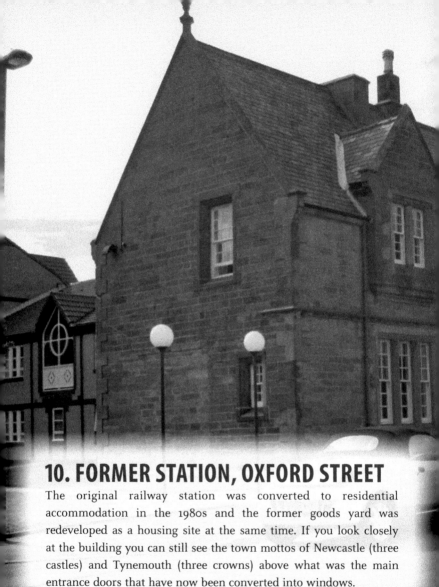

10. FORMER STATION, OXFORD STREET

The original railway station was converted to residential accommodation in the 1980s and the former goods yard was redeveloped as a housing site at the same time. If you look closely at the building you can still see the town mottos of Newcastle (three castles) and Tynemouth (three crowns) above what was the main entrance doors that have now been converted into windows.

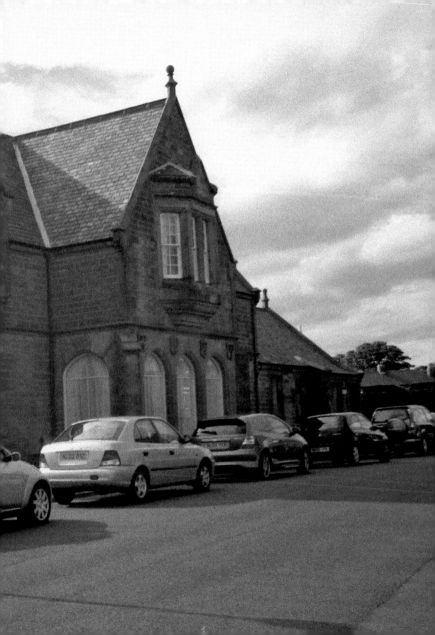

11. BLACK MIDDEN ROCKS

Before the construction of the north and south piers the entrance to the River Tyne for shipping was extremely hazardous. On the south side were a number of sandbanks known as the Herd Sands and on the north side were the notorious Black Midden rocks. Shipwrecks were very common when ships were blown onto the rocks and many lives were lost. Even after the construction of the piers, as seen here, ships still ended up stranded on the rocks if weather conditions were bad.

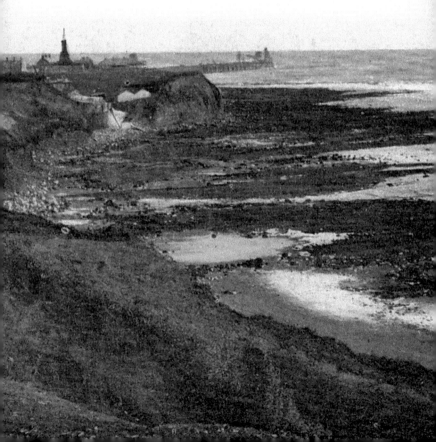

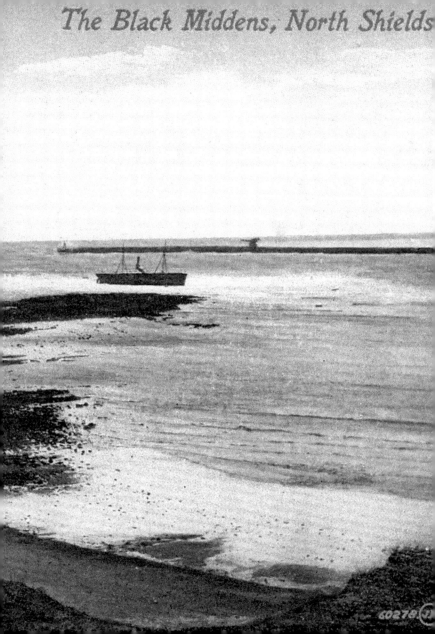

The Black Middens, North Shields

12. COLLINGWOOD MONUMENT, 1905

Cuthbert Collingwood who was born in Newcastle and spent most of his life at sea, became the hero of the nation in 1805 as he took over from the dying Lord Nelson to complete the naval victory at Trafalgar. Before he died Nelson, who was a very good friend, praised Admiral Collingwood as he led the attack on the French and Spanish ships. The monument at Tynemouth was erected in 1848 to commemorate Collingwood's role in this feat; the picture shows how it was decorated to celebrate the centenary of the battle in 1905.

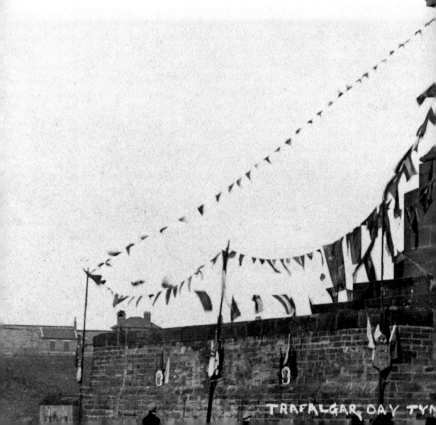

TRAFALGAR DAY TYN

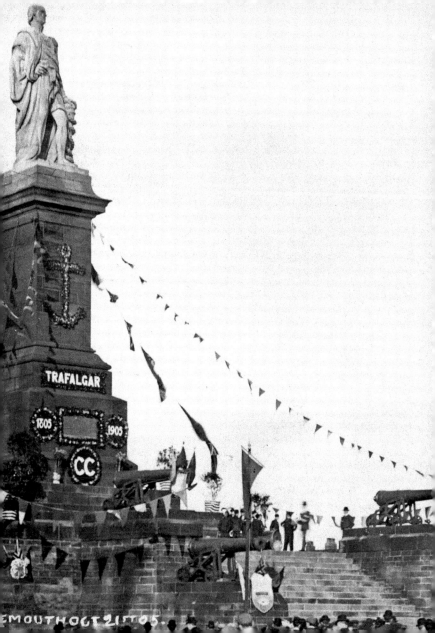

13. LIFEBOAT STATION AT BLACK MIDDEN ROCKS

This lifeboat station was constructed in 1865 directly on to the Black Midden Rocks to complement the original lifeboat station just a short distance away in Priors Haven. This was as a direct result of an unfortunate incident the previous year when the seas were so rough that the lifeboat based in Priors Haven had great difficulty in reaching the Black Midden rocks and a number of lives were lost.

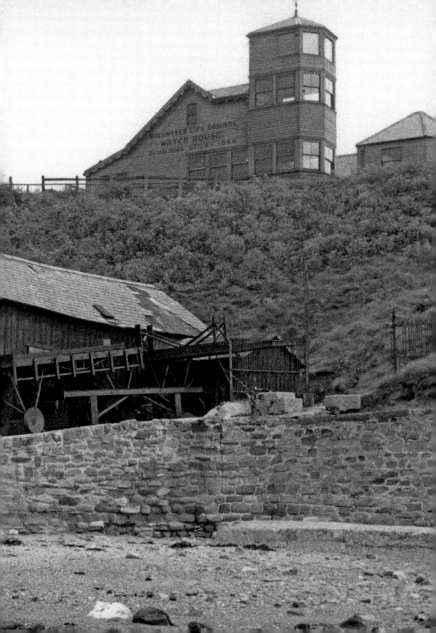

14. TYNEMOUTH VOLUNTEER LIFE BRIGADE HEADQUARTERS

Tynemouth Volunteer Life Brigade was the first of its kind in the world and was established in 1864 following the shipwrecks of the *Friendship* and SS *Stanley* on the Black Midden rocks on 24 November. The two vessels were grounded on the rocks during a fierce storm and, despite being only a few yards from the shore, thirty-six lives were lost including two lifeboat men. The Brigade Headquarters were erected in 1887 overlooking the mouth of the River Tyne.

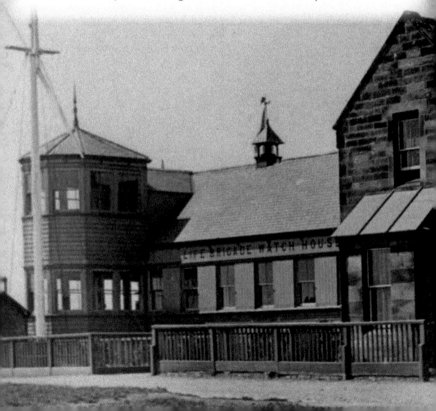

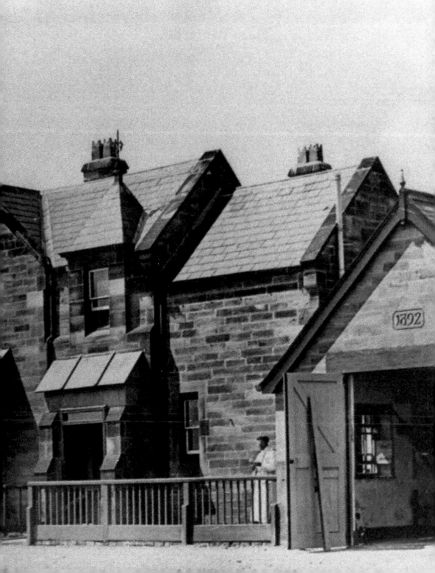

15. SPANISH BATTERY

All trace of the original Spanish Battery, built in 1545 by Henry VIII to protect the mouth of the Tyne and Tynemouth Castle, is now lost. The low stone-walled fort was named after the Spanish mercenaries who were based in it. The picture dates from before 1898 and, at that time, it still had the external brick walls and gun embrasures built above the original stone walls during the Civil War in 1643. It also had barrack buildings and storerooms within the Battery. During the Second World War gun emplacements were constructed around the headland and their concrete footings can still be seen below a number of wooden seats.

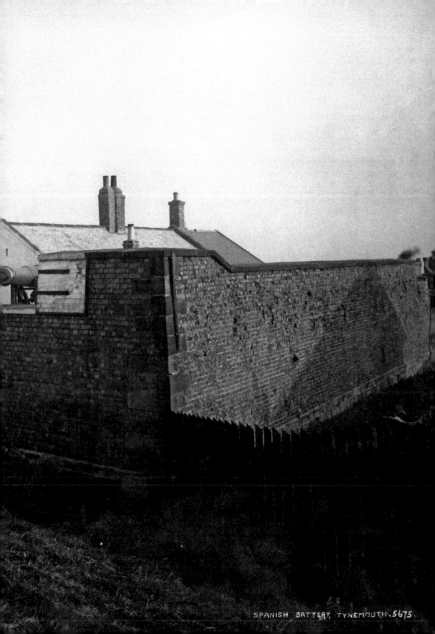

SPANISH BATTERY, TYNEMOUTH. 5675.

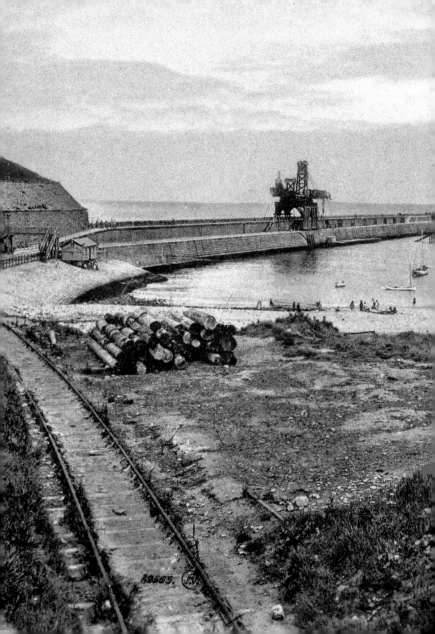

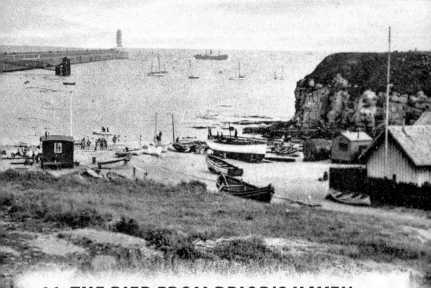

16. THE PIER FROM PRIOR'S HAVEN

Building work on the north pier commenced in 1855 but was beset with problems and took until 1909 to be completed. A railway line from Oxford Street brought materials to the 'Block Yard', now the site of the present car park, behind the Collingwood Monument. The great blocks of granite were prepared here then transported to the site by rail and lifted into place by the crane on the pier.

The Pier Tynemouth

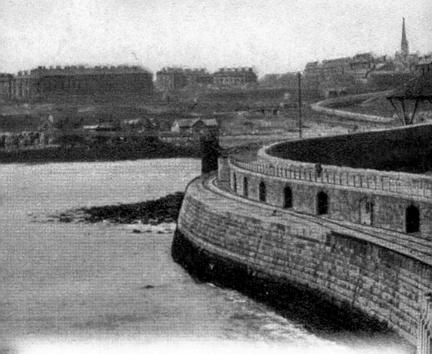

17. THE ORIGINAL CURVED PIER

The first north pier had a curved design similar to the pier on the south side and was completed in 1895. Unfortunately the design was flawed and it had to be replaced by a straight pier at a later date. The picture dates from before 1898 as the lighthouse can still be seen within Tynemouth Castle. The lighthouse was replaced by St Mary's Lighthouse in Whitley Bay in 1898 and demolished.

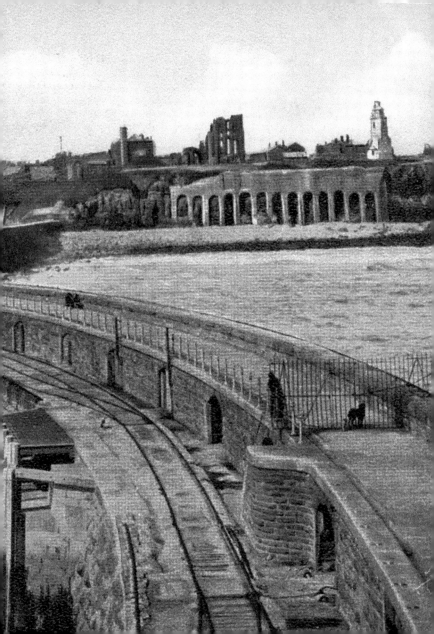

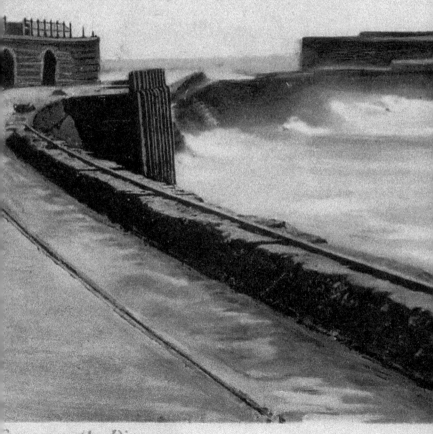

Tynemouth Pier.

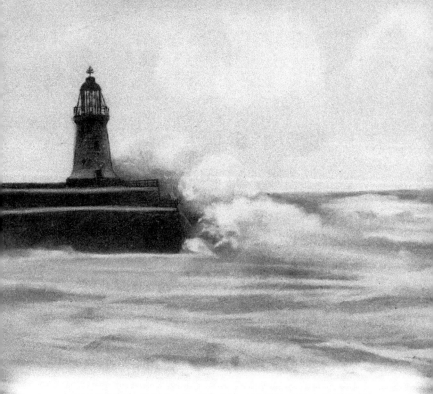

18. STORM DAMAGE TO THE ORIGINAL PIER IN 1897

In 1897, two years after completion, the original curved pier suffered terrible storm damage with more than 30 metres of the pier washed away. This isolated the lighthouse from the rest of the pier and the lighthouse keeper had to row between the gap to get to work. A new straight pier was built inside the earlier pier, which was used as protection from the storms. When the new pier opened in 1909 the old one was removed.

19. PIER APPROACH, PRIOR'S HAVEN

Looking north from Priors Haven and across the bridge over the pier railway is the road known as Pier Approach leading from Tynemouth Village. The large building on the right is the castle gateway which provided living accommodation for soldiers until 1936 when a fire destroyed this addition to the original gateway. All later buildings were removed and the original stone gateway was restored to its present appearance.

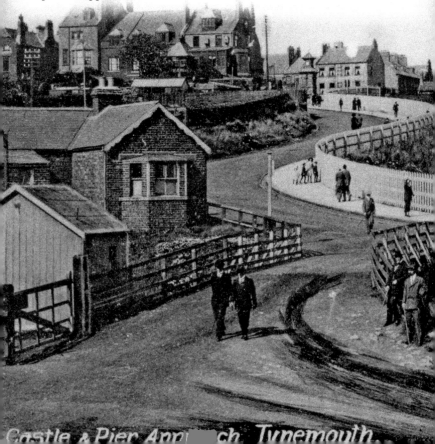

Castle & Pier Approach. Tynemouth.

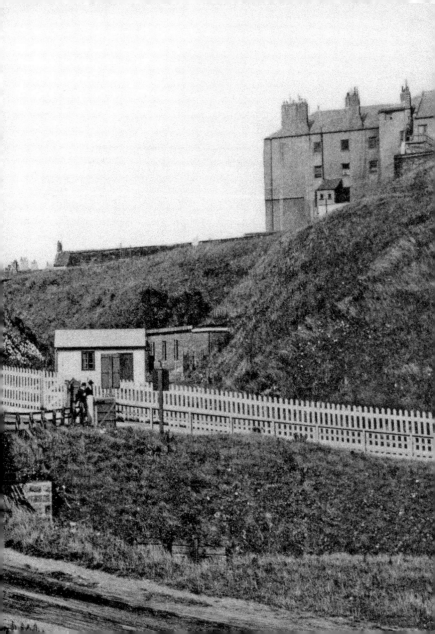

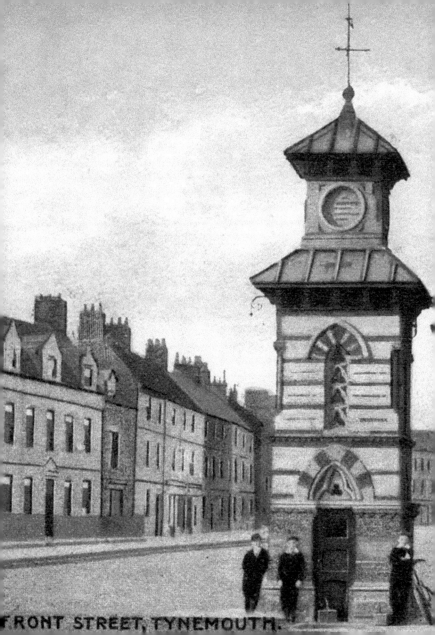

FRONT STREET, TYNEMOUTH.

20. SCOTT MEMORIAL FOUNTAIN, FRONT STREET

In 1861 William Scott of London presented this clock fountain to the Borough of Tynemouth as a sign of appreciation for his improved health after living in Tynemouth for some time to recover from illness. He was not the only person to take up residence in Tynemouth for health reasons as the famous female writer Harriet Martineau lived on Front Street between 1840 and 1845 in a property, now a guest house, which bears her name.

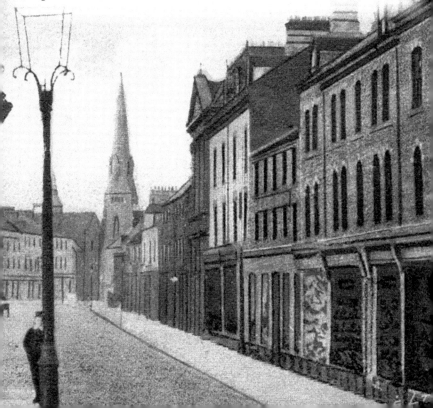

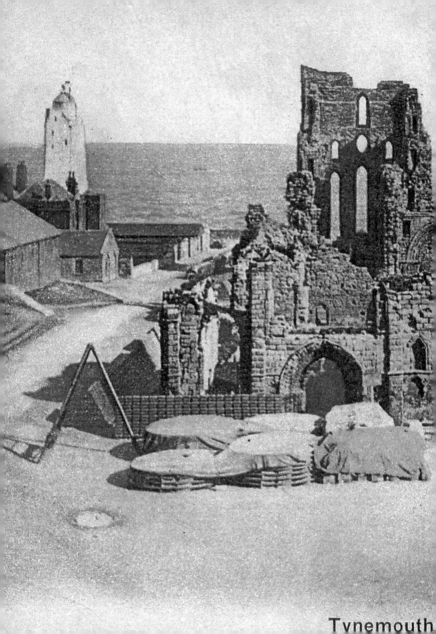

Tynemouth

21. TYNEMOUTH CASTLE & LIGHTHOUSE

Looking down from the gateway, a number of military items are stored in front of the remains of Tynemouth Parish Church, in the foreground with the priory ruins behind. To the left, barrack buildings are, in front of the lighthouse that was built in 1775 and demolished in 1898. The original curved pier can also be seen in the background.

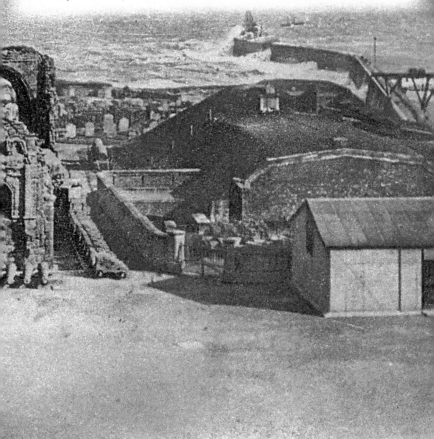

Castle Yard.

22. EAST STREET

In 1860, a number of buildings including a post office and grocery shop, tea and coffee rooms and the original Gibraltar Rock public house could be found to the east of Front Street in East Street. Most of these buildings above King Edward's Bay were removed in the 1930s with the Gibraltar Rock being the only survivor. Ralph Pigg was the grocer who ran the post office and John Marshall ran the tea and coffee rooms.

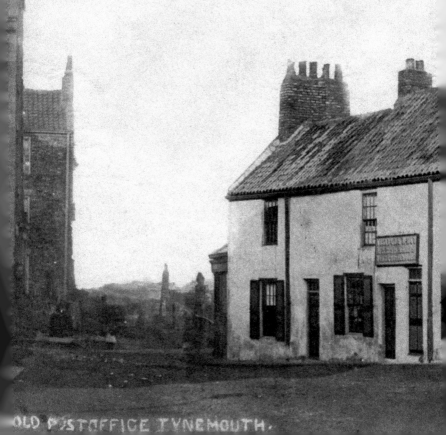

OLD POST OFFICE TYNEMOUTH.

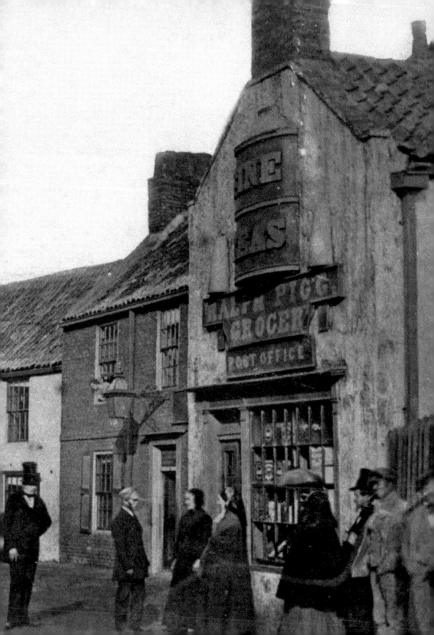

23. KING EDWARD'S BAY AND CASTLE

A number of barrack buildings can be seen inside the castle walls at the time this postcard was sent in 1909. There is a set of steps leading down into King Edward's Bay but no sign of the lower promenade and, as today, a number of people enjoy playing on the beach and paddling in the sea.

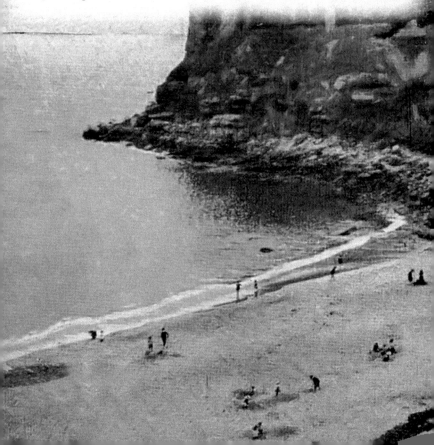

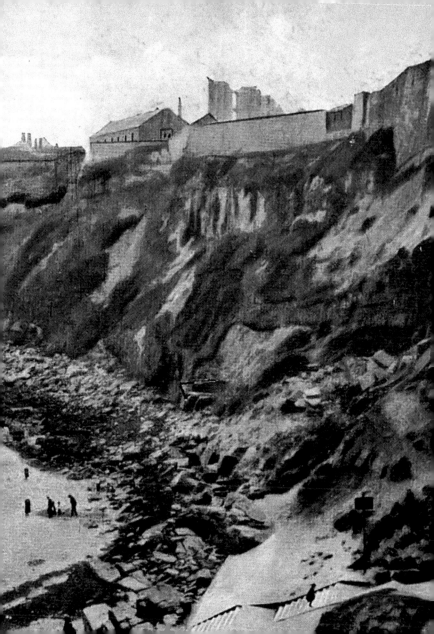

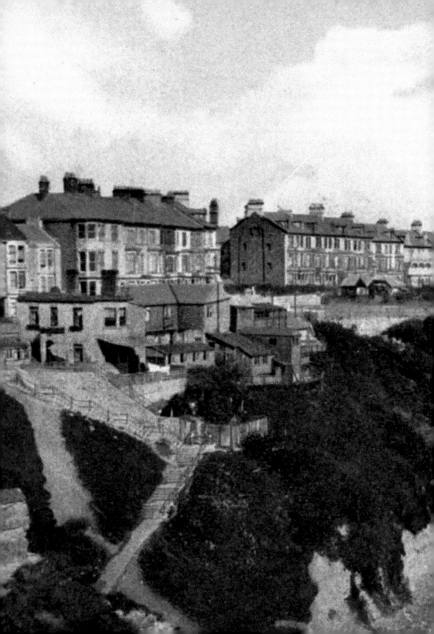

24. PERCY GARDENS

This prestigious curved terrace known as Percy Gardens was developed on land owned by the Duke of Northumberland and took the family name like many nearby streets. It was built from the 1870s but was not fully completed; it was not until the 1960s when the last gap site was filled in by modern flat-roofed apartments. The buildings backing onto King Edward's Bay were removed in the 1930s.

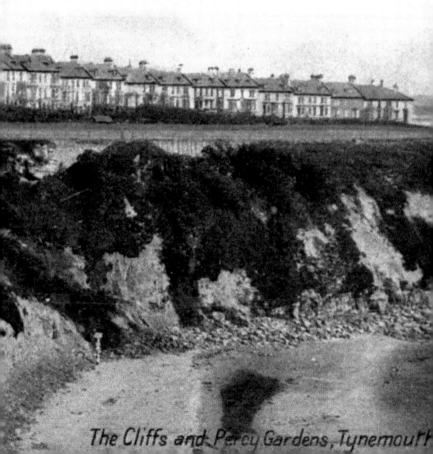

The Cliffs and Percy Gardens, Tynemouth

25. OUTDOOR POOL AND GRAND HOTEL

Tynemouth Outdoor Pool was built in 1925 and was popular for many years until modern indoor pools were built in the 1970s and it fell out of use. It was filled in with sand and rocks in the 1990s and, at present, there is a campaign to regenerate the pool. The Grand Hotel was built in 1872 for the Duke and Duchess of Northumberland as a seaside holiday home but was soon converted into a hotel. Stan Laurel and Oliver Hardy used to stop here when visiting the area as Stan spent some years as a youth in North Shields.

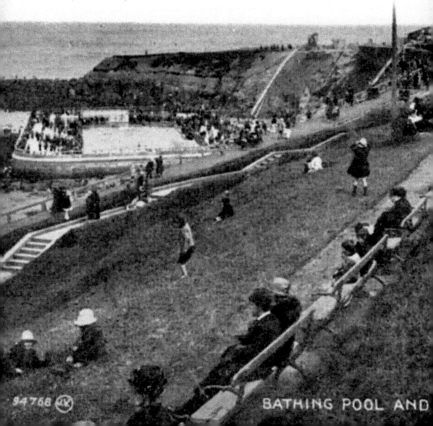

94768 ⊗ BATHING POOL AND

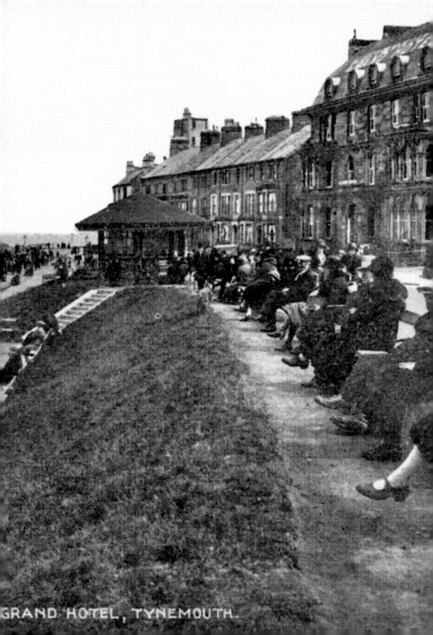

GRAND HOTEL, TYNEMOUTH.

26. LONG SANDS AND THE PLAZA

Tynemouth Long Sands were very popular in 1908, as seen from the crowds enjoying a paddle in the sea or using the rowing boats or the bathing machines (if you wanted more privacy). It would be nearly twenty years before the outdoor pool was built at the bottom of the picture. The beach is dominated by the Plaza or Tynemouth Palace that offered indoor activities when the weather was not kind.

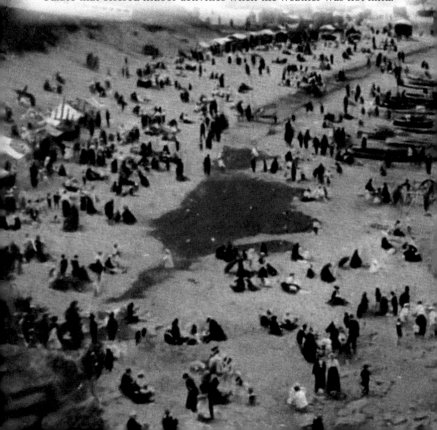

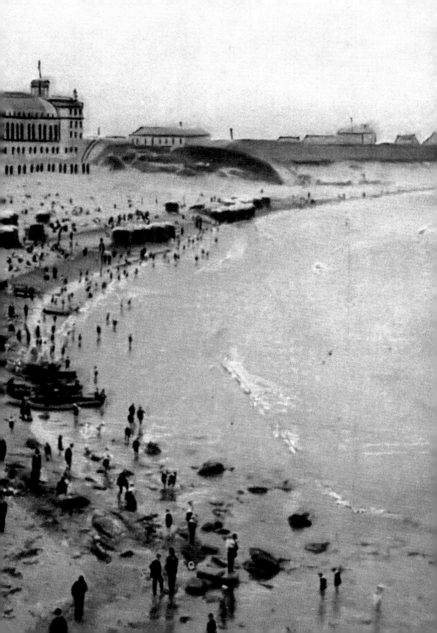

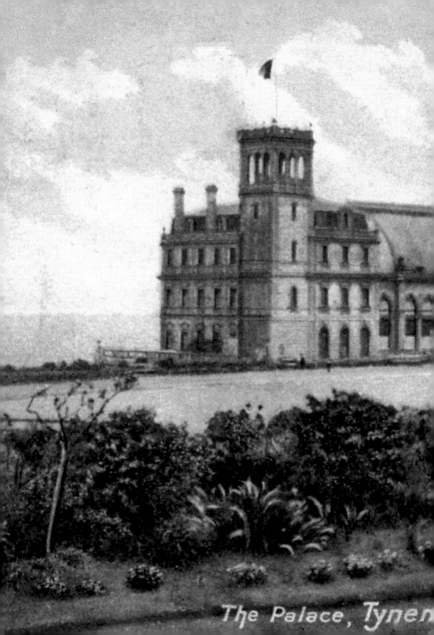

The Palace, Tyne

27. BOATING LAKE AND THE PALACE

The Palace at Tynemouth was built in 1878 and was a very imposing building but failed to live up to its potential and was a loss-making enterprise from the outset. It changed its name many times and was also known as the Aquarium & Winter Gardens, Gala Land and the Plaza. It also tried to reinvent itself by introducing new activities including a theatre, concert hall, tea rooms, aquarium, ballroom, roller skating rink, indoor market, amusement centre and nightclub but none were a success and it eventually burnt down in 1996. Tynemouth Park and boating lake were built in 1893.

outh.

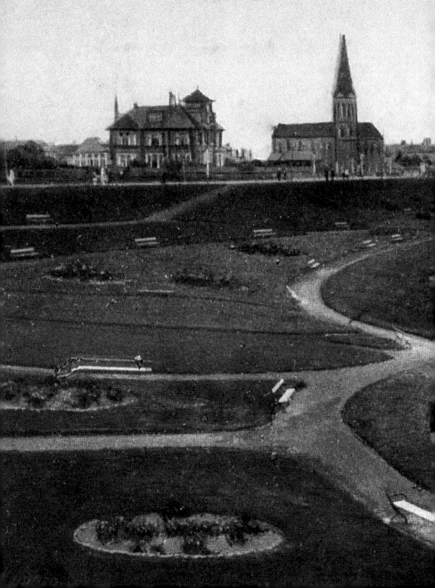

The Banks, Tynemouth.

28. THE BANKS AND
ST GEORGE'S CHURCH

Tynemouth Banks was the name given to the area between the Tynemouth Palace and Beaconsfield House and it was laid out with paths, flower beds and seating. A number of wooden beach huts were built by individuals, to a plan by the council, prior to the Second World War but they were all removed in 1940 and never replaced. In the background is the magnificent St George's Church, the only Grade I-listed building in North Tyneside. It was built in 1884 by the Duke of Northumberland and designed by the famous architect J. L. Pearson.

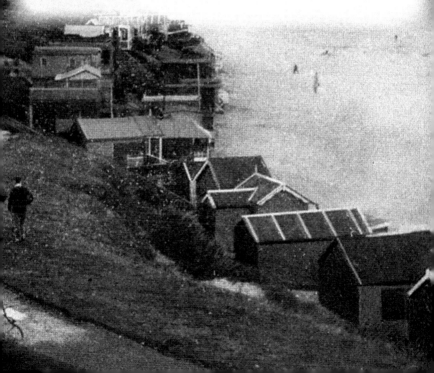

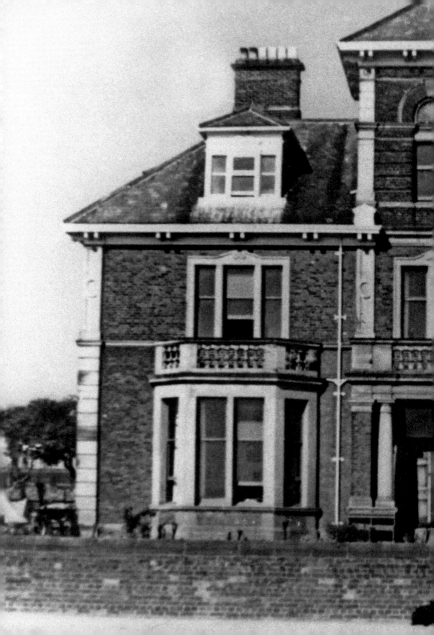

29. BEACONSFIELD HOUSE

Beaconsfield House was built by the coal baron John Henry Burns as a family home in 1882. It was later used by Barnardo's as a home from 1945 until 1957 when it was demolished and the land was eventually laid out in the 1980s as an open space and car park. The northern end was developed as the Blue Reef Aquarium in the 1980s beside the Park Hotel that was built in the 1930s.

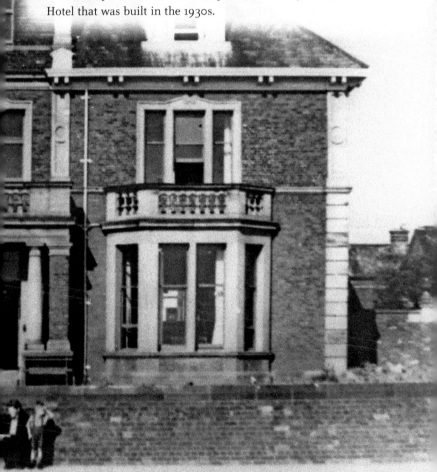

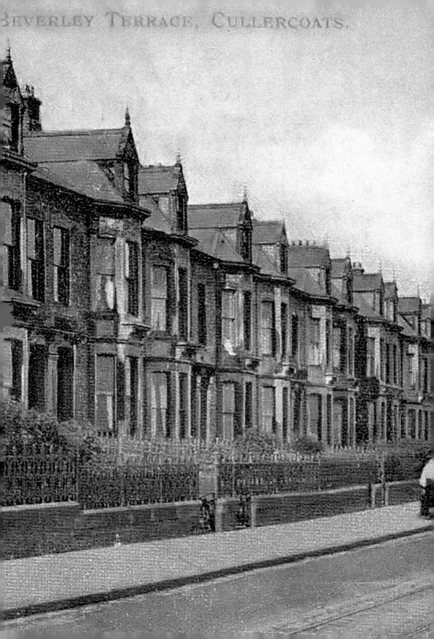

BEVERLEY TERRACE, CULLERCOATS.

30. BEVERLEY TERRACE

These imposing houses with views over the sea were built on land owned by the Duke of Northumberland in the 1870s and were named after Beverley in Yorkshire where he also owned land. They were built for the rich who also had the luxury of having three taps for water: hot, cold and seawater. Seawater was very popular at the time, with lots of perceived health benefits, and both Tynemouth and Cullercoats had seawater baths for use by the general public. Residents would be able to avoid having to use these public baths or bathing machines by taking the waters at home.

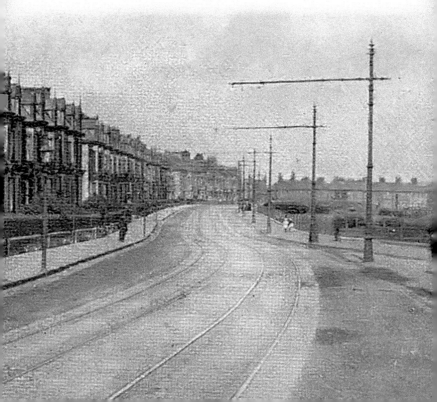

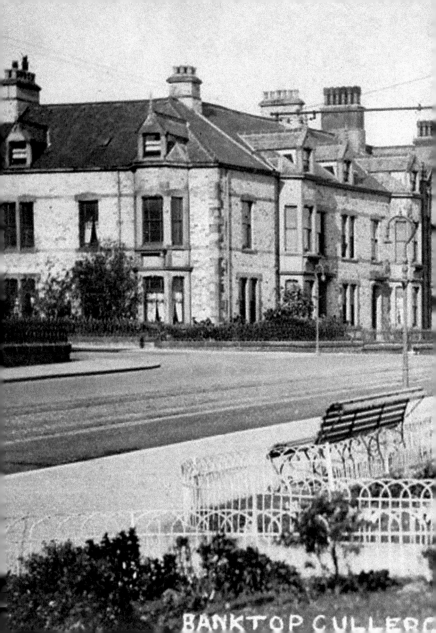

BANKTOP CULLERC

31. BANK TOP, CULLERCOATS

Bank Top, opposite Marden Avenue, was for many years laid out with decorative gardens and seating. In the background is the white Adamson Memorial Fountain which still exists today. It was put there by members of the Adamson Family to commemorate the life of a local man, Lt-Com. Bryan John Huthwaite Adamson, who was lost at sea together with eighty men on *The Wasp*, his first command, near Singapore in 1887.

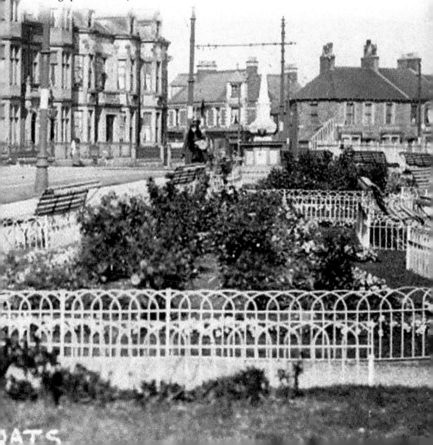

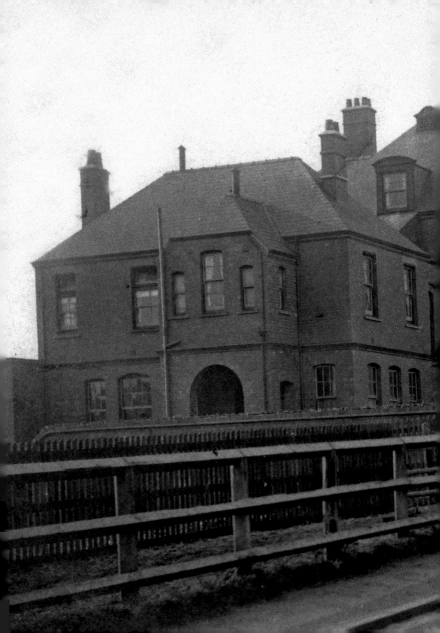

32. ST OSWALD'S HOME AND YMCA

This building was purpose built in 1891 as St Oswald's Church of England Diocesan Home for Friendless Girls at the top of Marden Avenue adjoining the railway line. It continued in use until 1939 and was later used by the YMCA; the site has now been redeveloped as flats for the elderly. The building could hold fifty girls as well as staff and replaced an earlier smaller building further down Marden Avenue. This building had originally held St Oswald's College for boys (who moved in 1886 to Tynemouth House to form the Kings School) and from 1891 had been a temporary home for the girls.

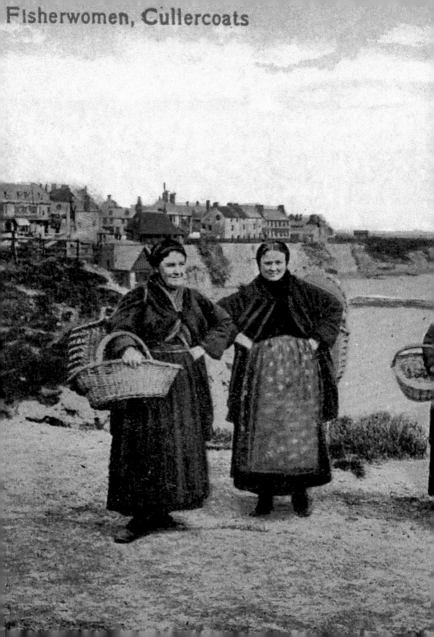
Fisherwomen, Cullercoats

33. CULLERCOATS FISHWIVES

Cullercoats fishwives were a well-known sight around Tyneside as they sold their fish all around the local area, carrying it in a creel or a basket on their back. They wore traditional dress comprising a print bodice with coloured neckerchief, a blue flannel skirt with a profusion of tucks, home-knitted stockings and stout but neat shoes. Their names are from left to right: Belle Storey, Barbara Storey, Mrs Ferguson, and Maggie Storey.

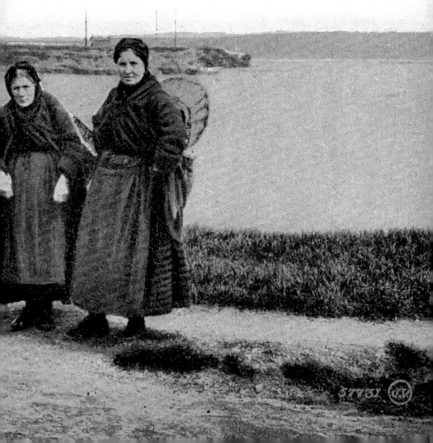

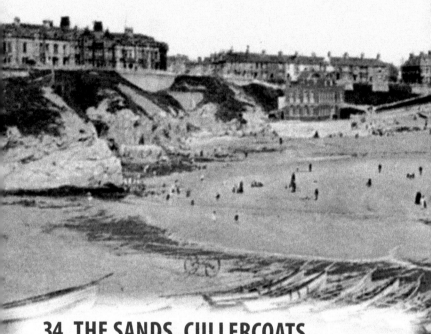

34. THE SANDS, CULLERCOATS

Fishing was very important to Cullercoats as evidenced by the number of boats on view at the time this picture was taken after 1908. The Dove Marine Laboratory can be seen in the distance and was built that year. The men would spend hours at sea fishing while their wives baited their hooks and sold the fish. The Lifeboat Station is the only other building on the beachside to the north of the Dove Marine Laboratory. It was first built in 1852 by the Duke of Northumberland and rebuilt in 1896.

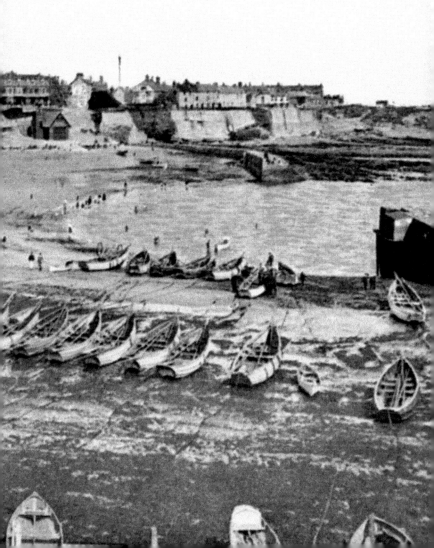

C_44268. CULLERCOATS: THE SANDS

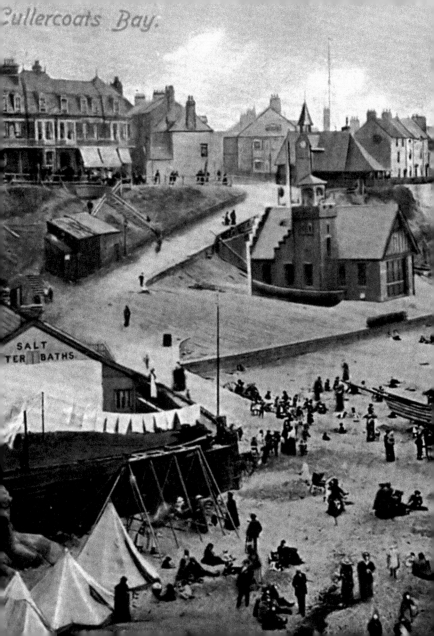

Cullercoats Bay.

SALT
TER BATHS

35. SALT WATER BATHS

The Salt Water Baths were built on the site now occupied by the Dove Marine Laboratory in 1807 by Richard Armstrong. Cullercoats became a fashionable watering place for the well-to-do. He advertised that there were commodious changing rooms, individual bathrooms, that the water could be changed at each high tide and could even be heated. The building with the clock and steep sloping roof, above the original lifeboat house, is the Watch House for the Cullercoats Volunteer Life Brigade, established in 1867 and the second oldest in the world.

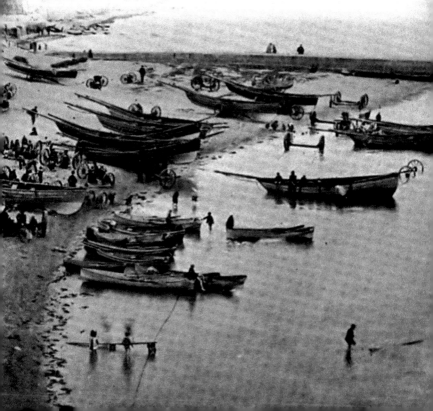

36. CULLERCOATS FROM THE NORTH-EAST

The Marden Burn watercourse forms the boundary between Cullercoats and Whitley Bay. The original buildings in Cullercoats were built right up to the watercourse valley before the valley was filled in and the water put into a culvert seen discharging onto the beach. These buildings were crammed together around the original manor house, called Dove Hall or Sparrow Hall, which is hidden amid these buildings that lay between Front Street and the sea.

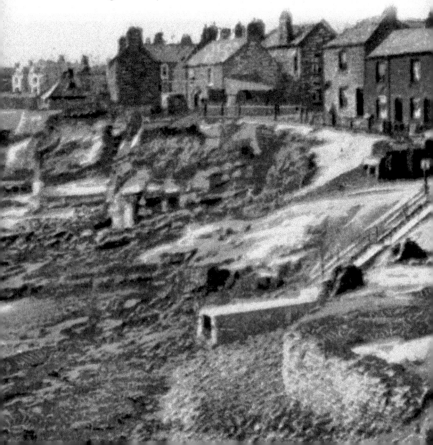

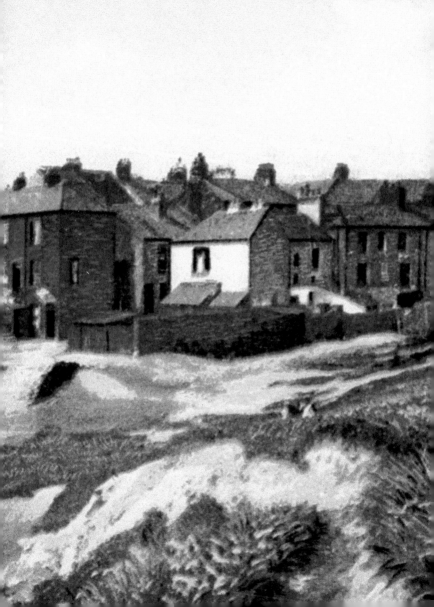

37. CULLERCOATS BAY FROM THE NORTH

The picturesque view of Cullercoats Bay, seen here with Tynemouth in the background, attracted many artists and, at one time, Cullercoats was regarded as an artist's colony. The most famous painter to live and work here (between 1881 and 1882) was the American artist Winslow Homer. Other well-known artists who painted here include John Wilson Carmichael, Robert Jobling, William Henry Charlton, Ralph Hedley, Victor Noble Rainbird, Miles Birket Foster and John Falconer Slater.

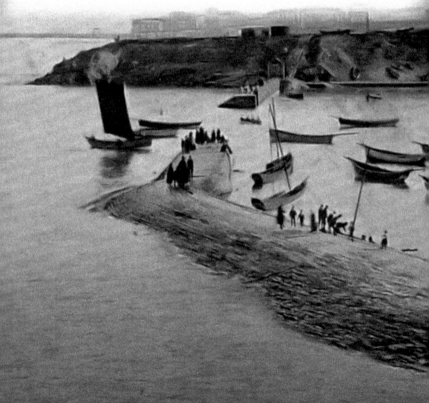

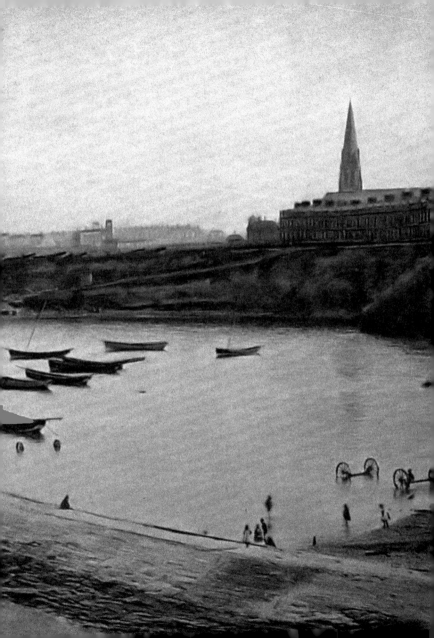

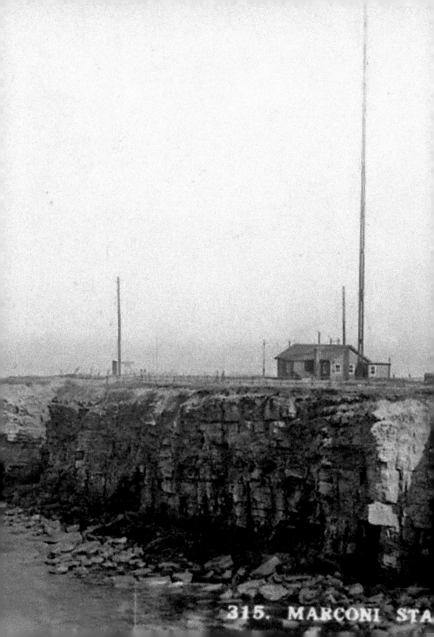

315. MARCONI STA

38. MARCONI STATION

The headland to the north of Cullercoats Bay is known as Marconi Point or Brown's Point but was originally called the Howlin and was where the fisherfolk hung out their washing to dry. In 1906 it became a radio transmitter station and, as it used Marconi equipment, it became known as Marconi Point. Over the years, different telecommunications masts were erected for communication with fishing vessels and other ships until 1996 when it was abandoned and the main building converted into a house.

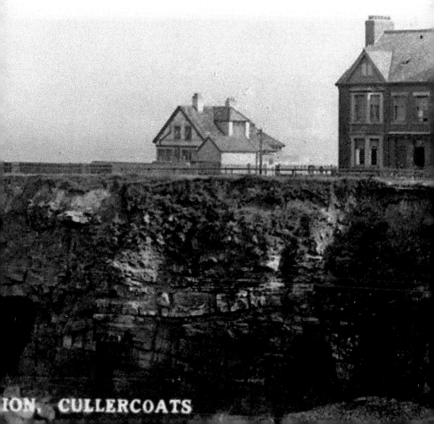

ION, CULLERCOATS

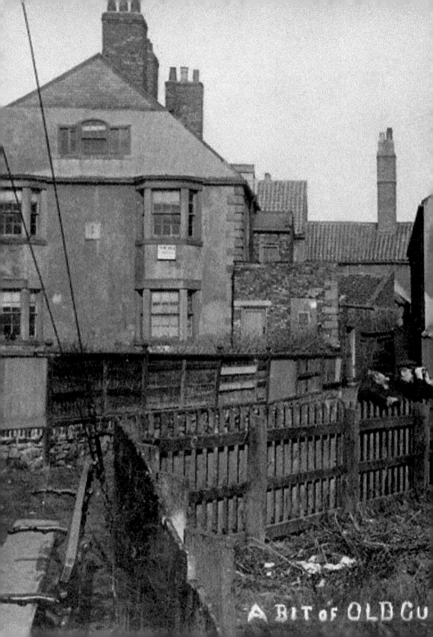

A BIT of OLD Cu

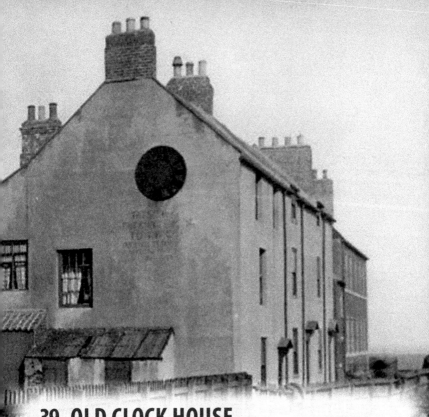

39. OLD CLOCK HOUSE

Dial House or the Old Clock House, on the end of the terrace overlooking the sea, originally had a clock on the gable wall until 1879 when it was moved to the newly built Watch House. The only building that still exists is Cliff House at the end of the terrace as all the others had to be demolished in 1936 following the collapse of the cliff. Cliff House was built in 1768 for Thomas Armstrong who was said to be the Customs Officer as well as a smuggler. Winslow Homer used one of the houses on Bank Top as his studio.

40. SPARROW HALL

Built in 1682, Sparrow Hall was said to be the oldest house in Cullercoats. The old Jacobean manor house was built in its own grounds overlooking the sea. It was correctly named Dove House after its owner but as the carving of a dove on the side looked more like a sparrow it inherited its new name from the locals. Over time, many houses were built beside it in the grounds and the hall was subdivided. It was demolished in 1969 to make way for a seafront village green.

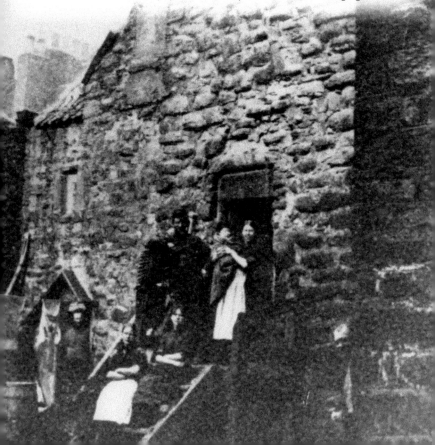

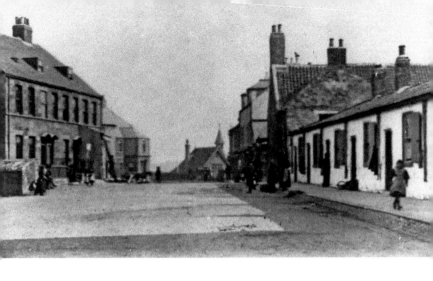

41. FRONT STREET LOOKING TOWARDS THE WATCH HOUSE

The Watch House can be seen at the end of Front Street with a row of whitewashed fishermen's cottages on the right side and part of the gable wall beside the Queen's Head public house on the left. The Queen's Head dates from at least 1828 when it was described as 'a desirable retreat during the Bathing Season'. It is now the oldest surviving building on Front Street.

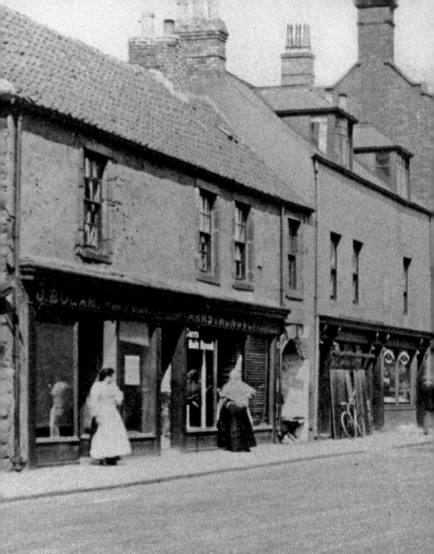

FRONT St CULLERCOA

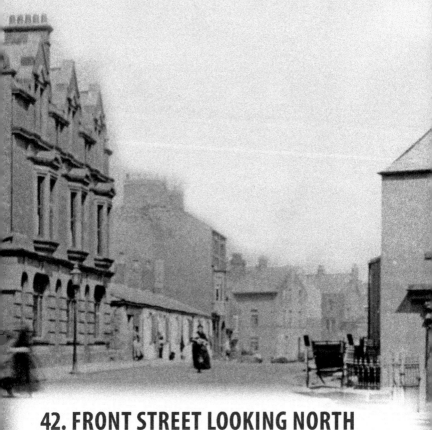

42. FRONT STREET LOOKING NORTH

This view of Front Street is dated from around 1906 and is taken from outside the Watch House looking north. The large building between the shops and the fishermen's cottages is the Ship Hotel, built on the site of an earlier Ship Inn. Just off picture to the left would have been The Bay Hotel where Winslow Homer lived during his stay in Cullercoats and, at that time, may have been called the Hudleston Hotel.

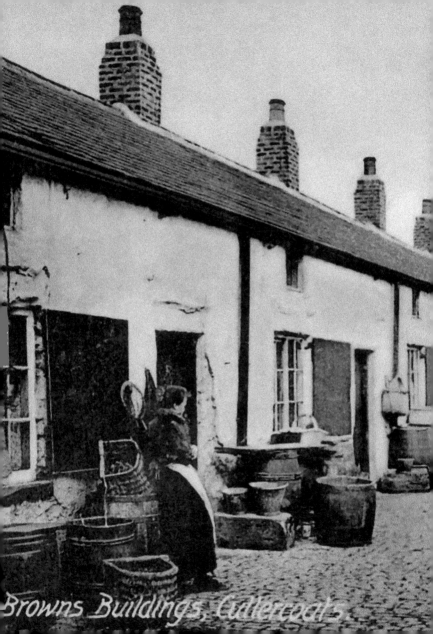

Browns Buildings, Cullercoats.

43. BROWN'S BUILDINGS

Set back between Front Street and Simpson Street was a row of nine traditional fishermen's cottages known as Brown's Buildings, seen here in 1895 and built around 1836. They were probably named after Robert Brown, the local grocer who also ran the village post office. They were accessed by a narrow alley off Front Street behind more fishermen's cottages at Nos 27–33 Front Street.

44. HUDLESTON STREET

Hudleston Street was named after the Hudleston Family who owned land in Cullercoats for many years and had married members of the Dove Family who were also local land owners. It was Wilfred H. Hudleston who gave the money to build the Dove Marine Laboratory in 1908 which was named after one of his predecessors, Eleanor Dove, who married Revd Curwen Hudleston in 1792. One of the nearby streets was named Eleanor Street after her as well. The street was redeveloped in the 1980s and new housing is built in Hudleston Courtyard.

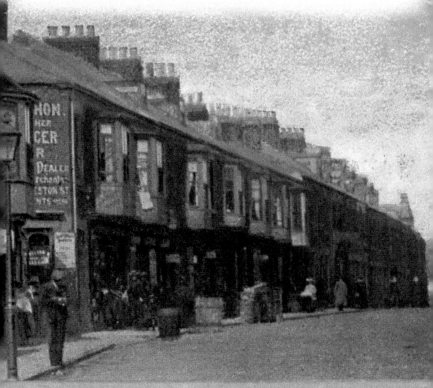

Hudleston Street, Cullercoa

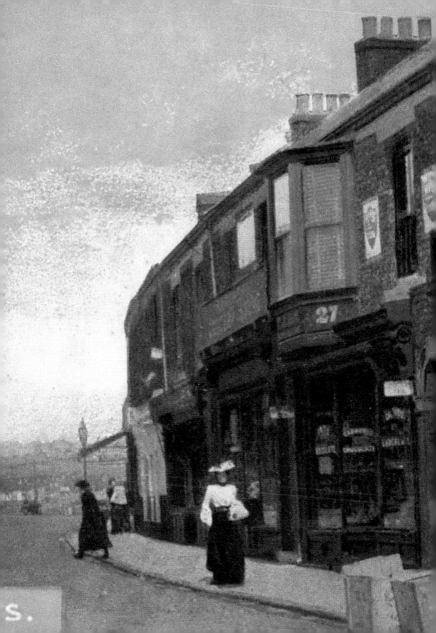

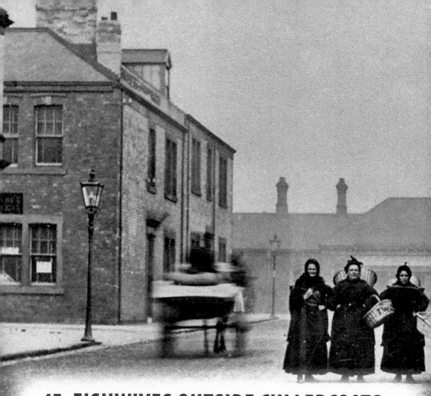

45. FISHWIVES OUTSIDE CULLERCOATS STATION

A number of Cullercoats fishwives are seen here, around 1913, in Station Road on their way back home from Cullercoats Station, seen in the background. They travelled all over the area selling their fish and, at one time, they were banned from travelling on the local trains during peak times. This was because of the smell of the fish in cramped conditions when travelling with well-to-do businessmen on their way to Newcastle. A compromise was arrived at and they were allowed to travel on the trains after 9.30 a.m.

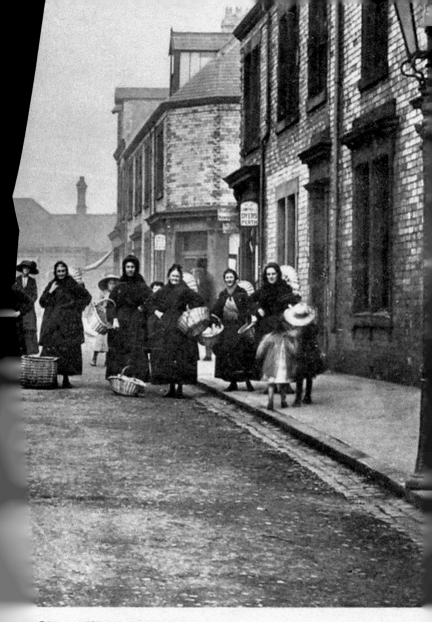

ON. CULLERCOATS.

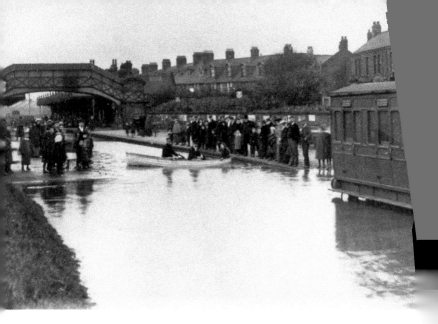

46. CULLERCOATS STATION FLOODED

There have been a number of occasions when the tracks beside Cullercoats Station have flooded and rowing boats have been deployed to rescue stranded passengers. One such occasion was on 26 October 1900 when it took more than two hours to rescue the passengers. The train had passed through Cullercoats Station but hit a great body of water on the track that extinguished the engine and stopped the train. The station was also flooded in May 1924 and July 1926.